This endeavor was born out of a gift card, a friend saying she thought I could learn to watercolor, online tutorials, and a global pandemic. Just like that these little birds and I started telling the stories of Covid-19. Thank you to Amanda, Lindy, and Lisa for your much needed expertise in taking this book to the next level.

The intention of this book is to bring levity to a horrific situation. It will be remembered as a time of loss for individuals, communities, families and so much more. Hopefully we will be able to remember some things with subtle joy.

Karrie Funk

How ya doin' in there?

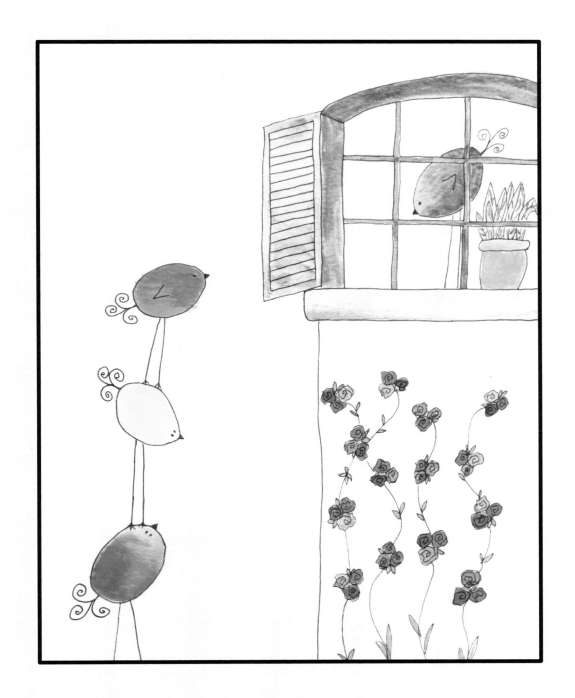

Happy Homeschooling

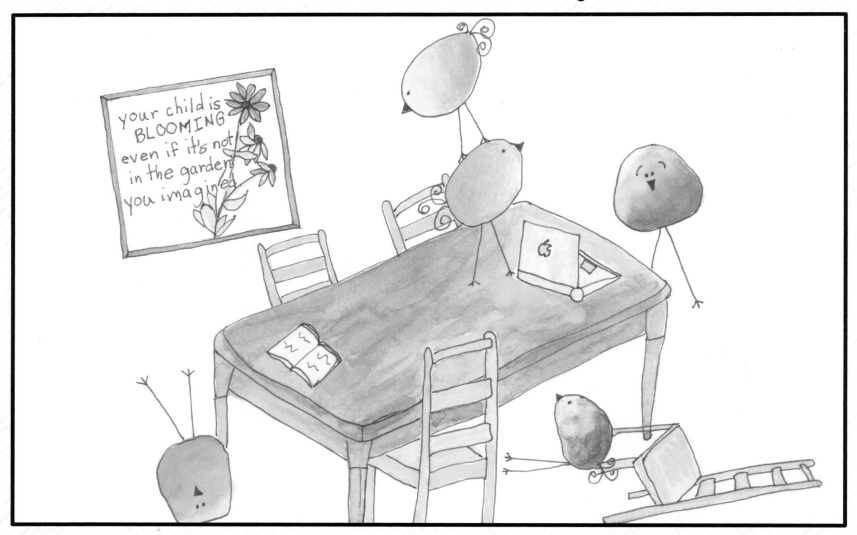

Out of the classrooms and into the homes. E-learning looks like a mix of worksheets and computers. No one knew the measure of "too much" or "not enough." Everyone (parents, kids, teachers and administration) was doing the best they could.

A New Kind of Shopping List

In one hand, your grocery list of necessities. In the other, a reminder list of new protocols. What was once routine was now an obstacle course of keeping distant, following arrows, breathing through a mask, and not forgetting the toilet paper (if you could find any).

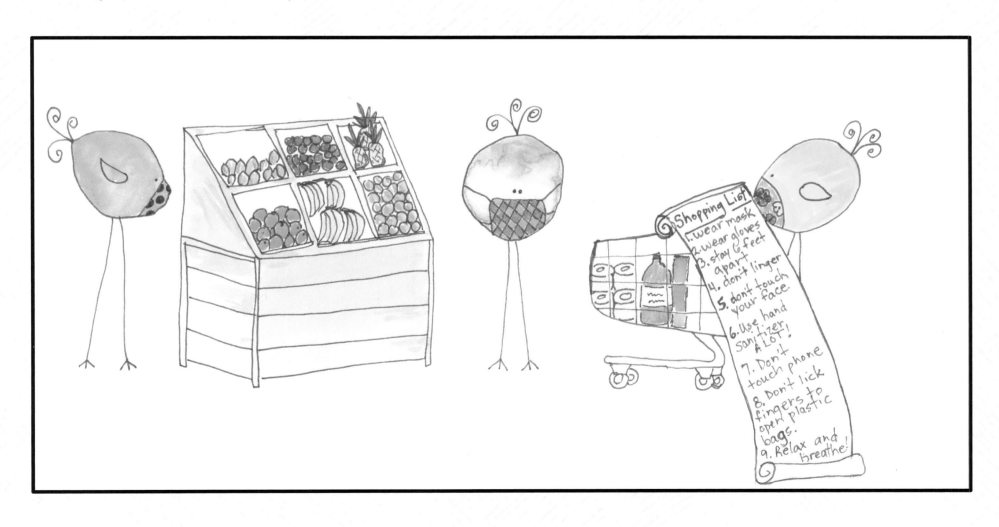

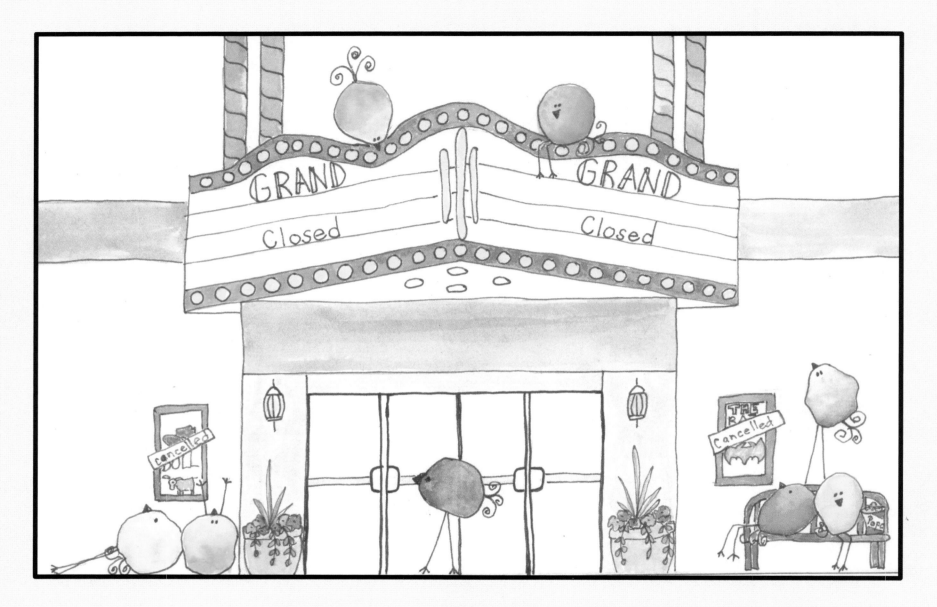

OK, we will just wait!

Beyond stores, churches and schools, our favorite gathering places
were forced to close as we try to "flatten the curve".

Online Church?

Families are relieved of rushing to church on Sunday mornings. No more outfits snafus, forgotten Bibles, or disagreements in route. During the pandemic we got to flip on our TV, tune in to our local congregation and bicker from the comfort of our own homes.

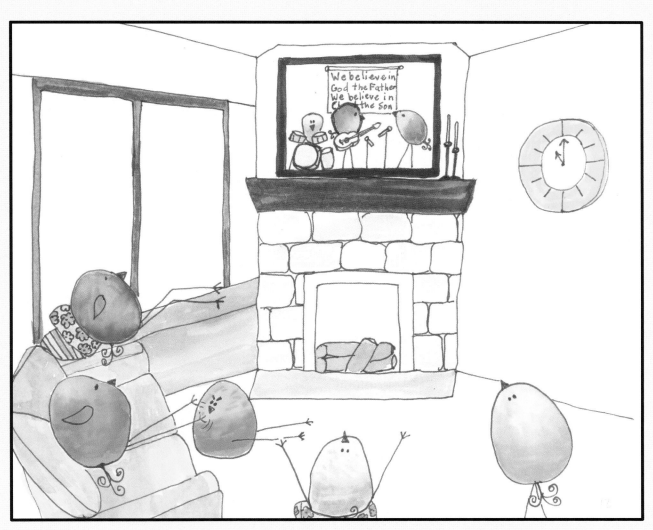

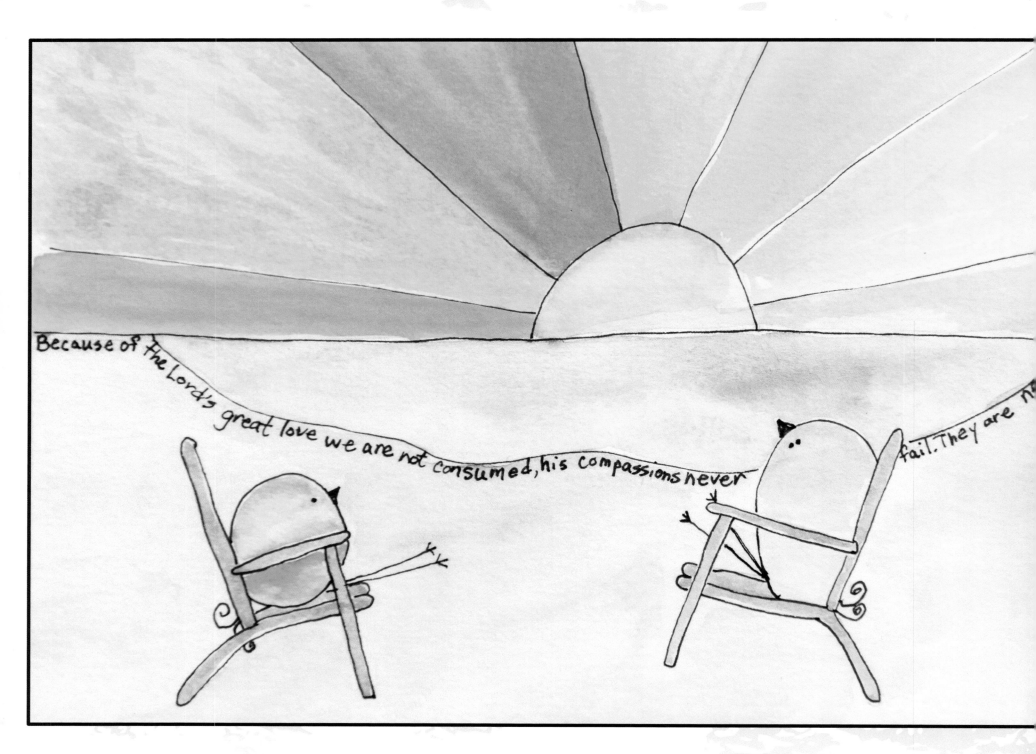

ry morning.

Easter

Celebrating the resurrection

of Jesus happened

differently for each family.

The truth of Easter remained the same.

No pandemic can take away

the hope we have in our risen

Lord.

Easter (bird) Bunnies

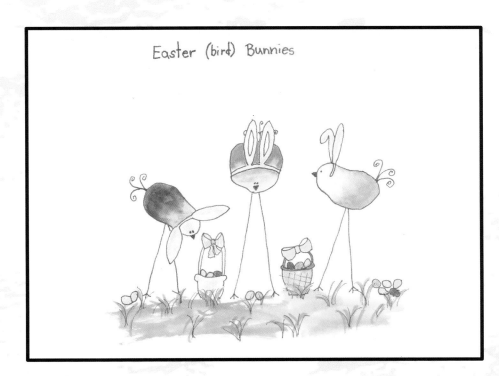

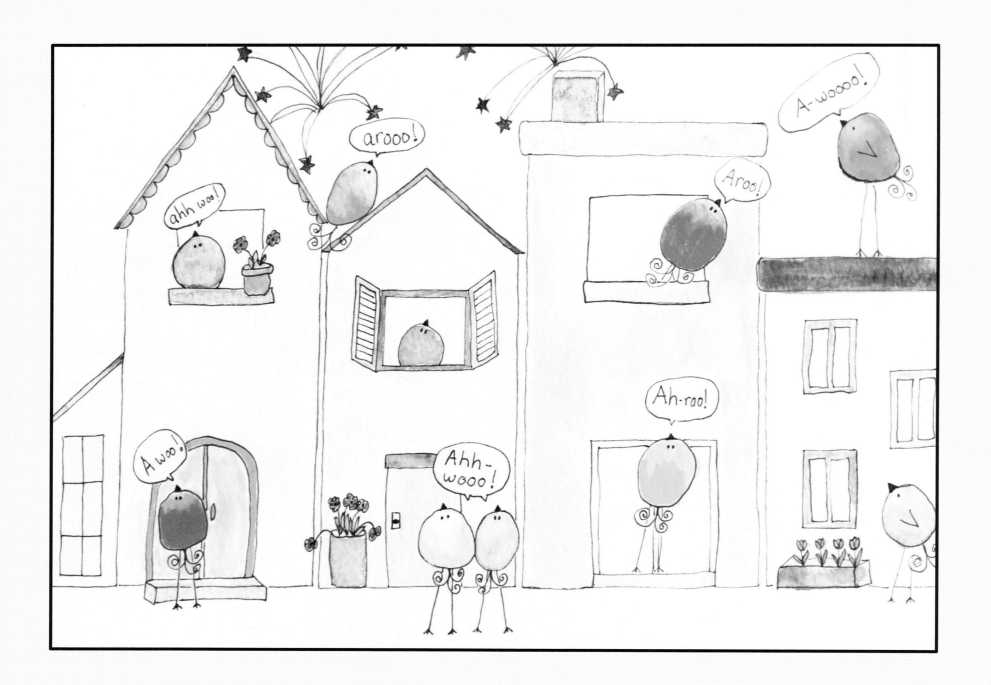

Creative Connection

Globally and locally we saw imaginations at work. People stepped out of their isolation to howl, play music, or ride golf carts through their neighborhoods. Human interaction was a must.

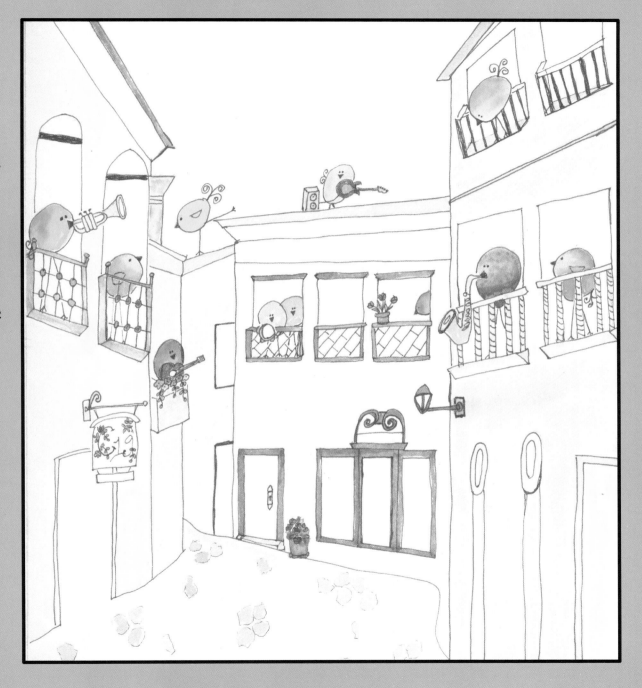

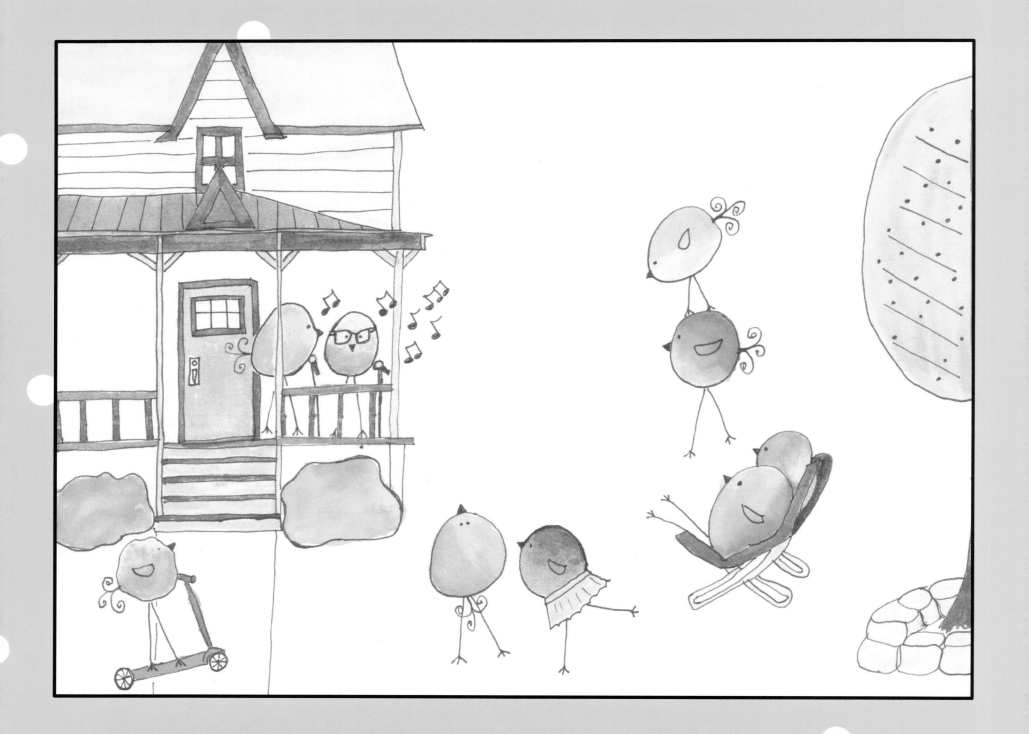

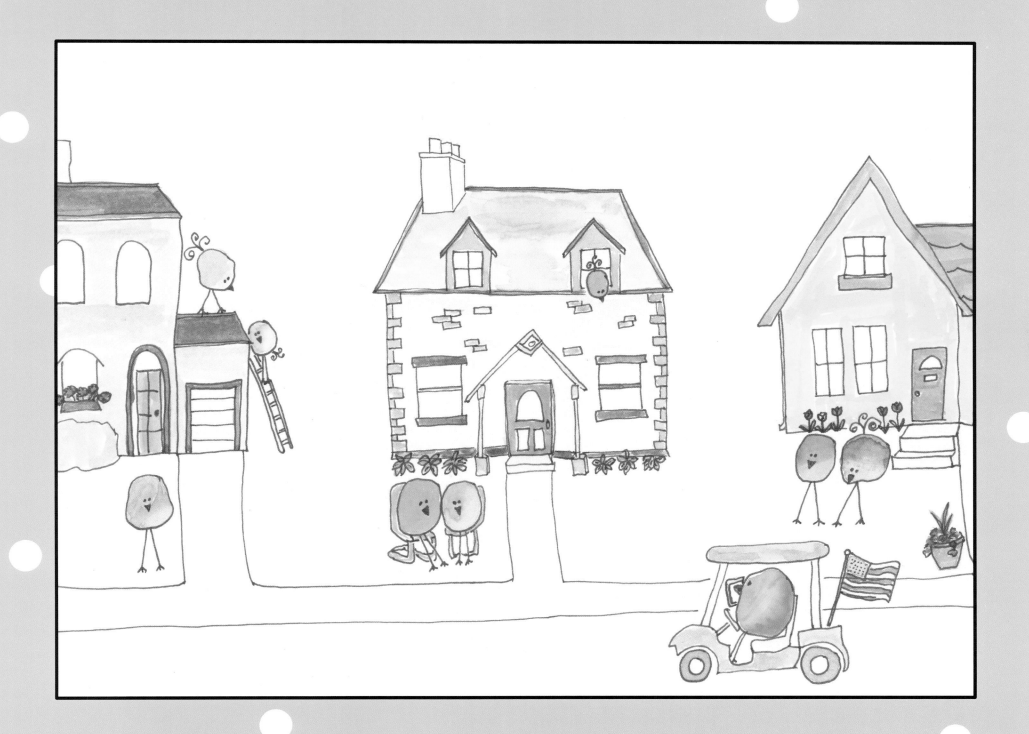

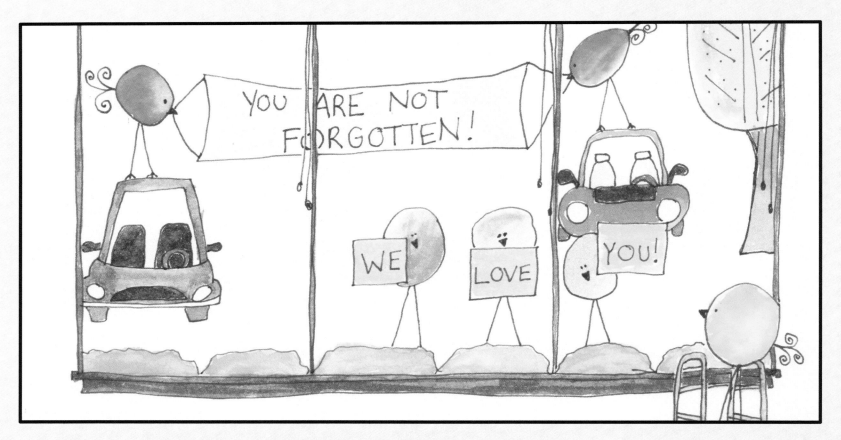

Careful Connecting

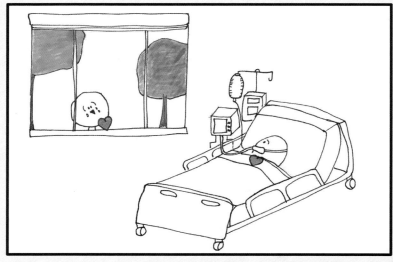

COVID-19 stole our ability to be with vulnerable loved ones. Stories of isolation and broken hearts were heard daily. Intentional efforts were made so that they did not feel forgotten.

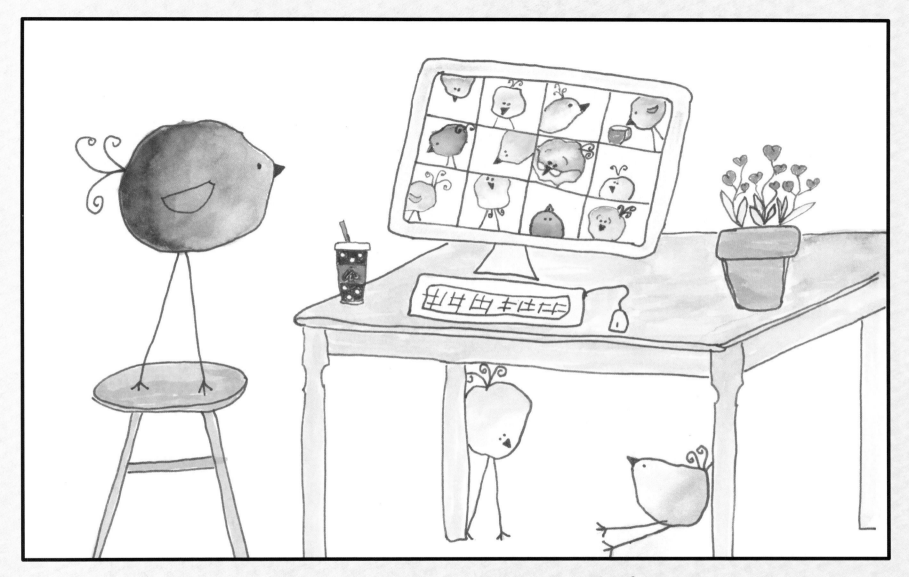

Video Chats are a Beautiful Thing

2020 was the year of computers and phones. From work to family check-in's, to girl's nights and college classes, and everything in between. These video chats became a part of daily life.

Everyone Loves a Parade

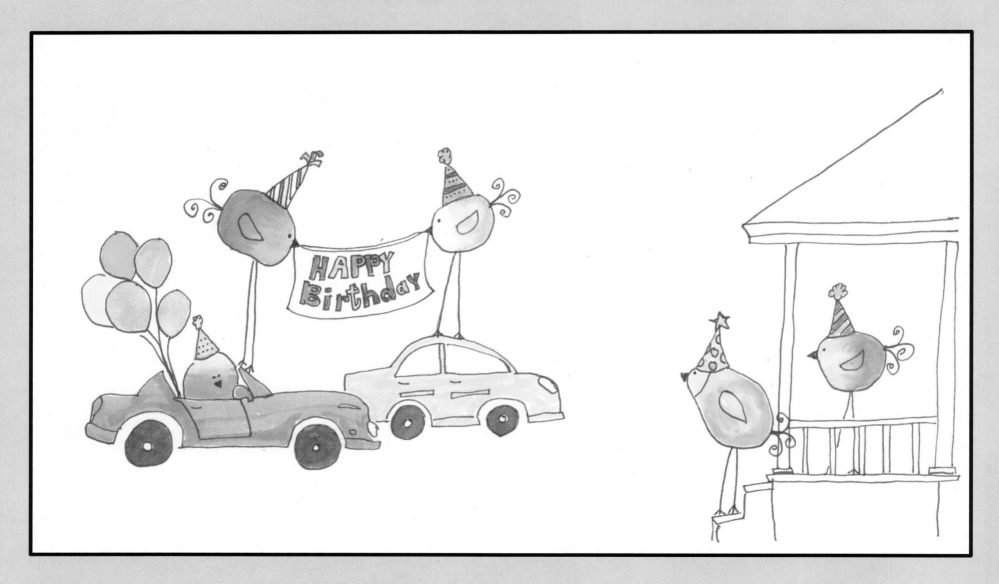

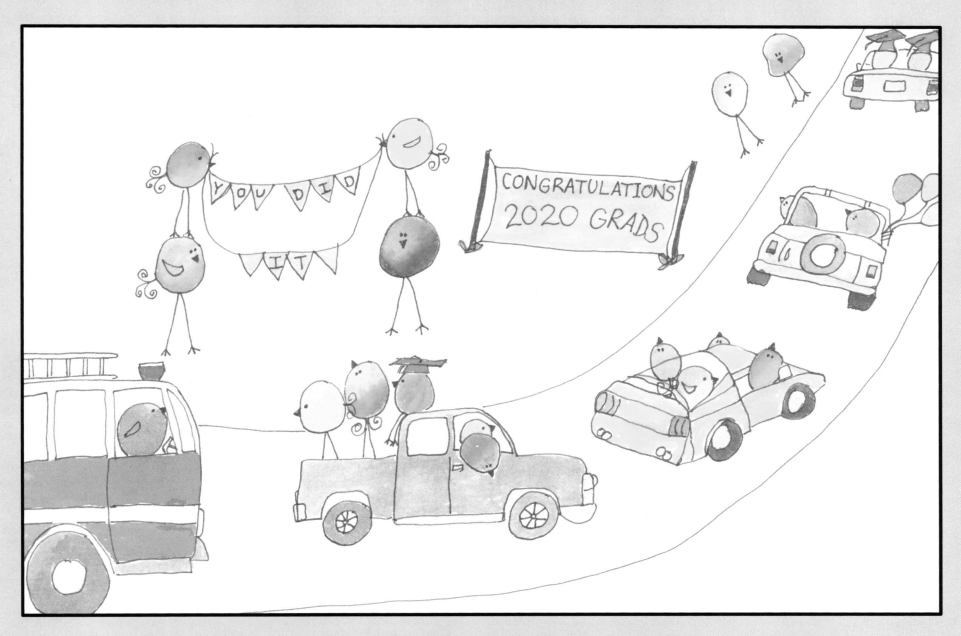

A pandemic can make life look abnormal but it can't stop birthdays, graduations, and other celebrations.

To Thine Own Device Be True

Screens. Lots of screens. For the parents it was a love/hate relationship.
For the kids it was all love.

Where's Mom?

Schools. Parks. Churches. Visiting friends. Library. Work. Everything was closed and parents' ability to get a bit of quiet time was hard to come by.

What's For Dinner?

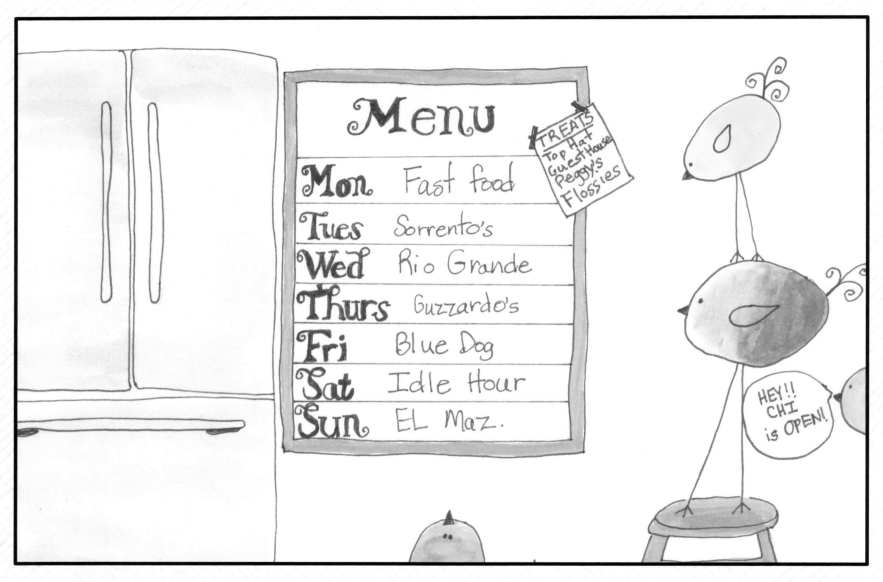

As restaurants and favorite hotspots learn to safely open up, we home chefs were more than happy to do our part in boosting local economy.

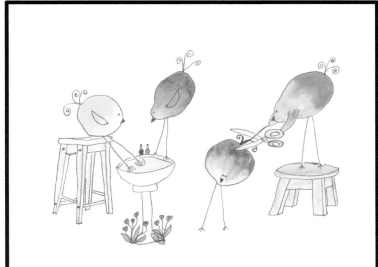

Desperate times call for...

Salons and barbershops were hit hard during quarantine. Some brave souls tried pampering themselves while others let their tail feathers grow and waited for the pros.

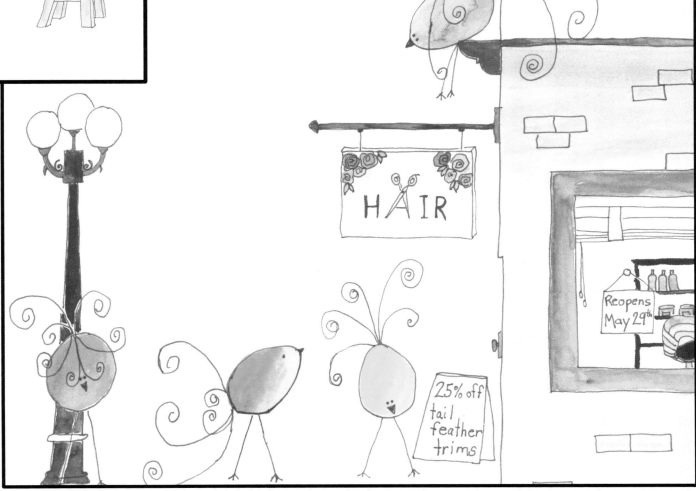

If We Have to Wear Them We Might as Well Have Fun!

As life proceeded, with some alterations, we continued to show our creativity, hopeful spirits and desire to connect with one another. We waited for life to get back to normal. Maybe this is the new normal?

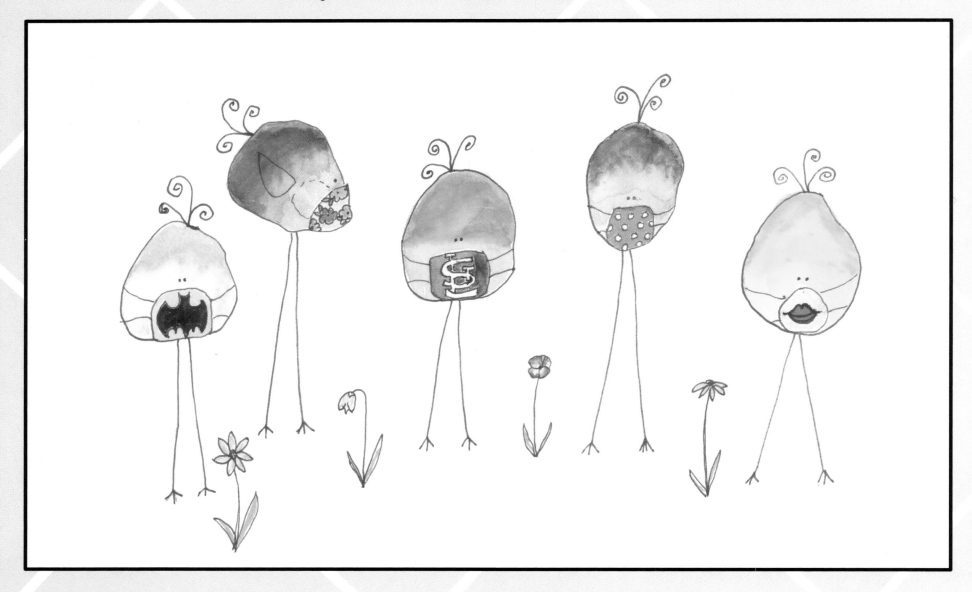

About the Author

Karrie is married to the love of her life, Tom and has three amazing college age children; Abby, Julianne and Noah. They make their home in Lincoln, Illinois. Karrie was a registered nurse for 15 years and then chose to be an at-home mother. Now she enjoys working with preschoolers. In her spare time she would love to say she enjoys gardening, cooking and exercise but alas she is most joyful being with friends, listening to podcasts, and creating beautiful things.

CPSIA information can be obtained at www.ICGtesting.com
Printed in the USA
LVIW012355111120
671366LV00016B/243